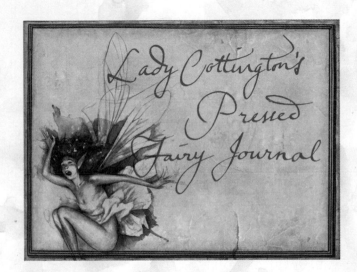

First published in Great Britain in 1996 by
Pavilion Books Limited
London House, Great Eastern Wharf,
Parkgate Road, London SW11 4NQ

Text by Terry Jones copyright © Fegg Features Ltd 1994

Illustrations copyright © Brian Froud 1994

Designed by Wherefore Art?
Calligraphy by Ruth Rowland

A CIP catalogue record for this book is available from the British Library.

ISBN 1 86205 024 4

Printed and bound in Singapore by Imago

2 4 6 8 10 9 7 5 3

This book may be ordered by post direct from the publisher.
Please contact the Marketing Department.
But try your bookshop first.

PAVILION

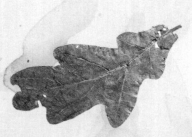

Publisher's Note

The RSPCF (the Royal Society for the Prevention of Cruelty to Fairies) has asked the publisher to make it clear that no fairies were injured or killed during the manufacturing of this book. The pictures in this book are *psychic impressions* of fairies. The RSPCF would also like to point out that, after one or two unfortunate casualties in the early stages, all the fairies presented in these pages had discovered a way of leaving their psychic imprint without suffering any physical harm themselves. In fact, the whole process became recognised as a *Fairy Sporting Activity* and qualified for a Gooseberry Medal at the Millennial Fairy Olympics in 1921.

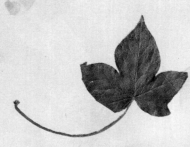

Everyone is familiar with the famous photograph of the small girl surrounded by fairies, which caused such a sensation when it was first published in *The Regular* magazine in 1907. It inspired many imitations and was circulated around the world. Until recently, surprisingly little was known about the young girl in the photograph. It was only known that her name was Angelica Cottington, and that she was the only daughter of Lord Cottington of Bovey. On the death of her father, Angelica became Lady Cottington, and lived as a recluse on the family estate. She never married and had no friends or even acquaintances other than her housekeeper, Ethel, and she did not even know her very well.

After Lady Cottington's death in 1991, a short-sighted antiquarian bookseller, of no fixed abode, discovered a small volume behind a trunk in the attic. Having run out of cigarette papers, he was just about to tear out some pages, when he happened to put on his glasses (in order to distinguish the Morocco Gold from the Damascus Hemp) whereupon he immediately recognized the importance of his find. Thanks to this chance discovery, you are now holding in your hands a faithful reproduction of one of the finest roll-your-own aids of all time — *Lady Cottington's Pressed Fairy Journal.*

Here is a faithful record of the fairies who appeared to Angelica Cottington throughout her earliest years. And not only written accounts — for this book is nothing less than a physical record of actual living fairies. Lady Cottington kept a detailed diary of her fairy sightings and this is reproduced here, alongside the pressings of the fairies themselves and the fairy calendar. Angelica Cottington discovered that if she sat still with the book upon her lap, fairies (being inquisitive creatures) would come fluttering around her, and with a sure eye, a quick lunge and a firm snapping together of the book she could catch the fairies between her pages and thus preserve their appearance for posterity.

I hope this journal will bring lasting pleasure and happy memories to those who are already familiar with the fairy world, and for those who have not as yet been granted that privilege, I hope this book will bring some illumination.

Terry Jones

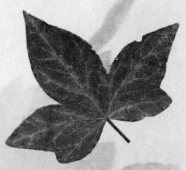

A Brief Word about the Fairy Calendar

To the human observer, it may seem that there are a lot of fairy anniversaries, celebrations, and holidays. In fact, there are comparatively few days that are not. Unlike humans, fairies consider the act of enjoying oneself to be superior to the act of 'making money' or 'taking life seriously' or 'justifying one's own existence' or 'being a credit to oneself'. Fairies think all that sort of thing is plain daft. There are, therefore, few days in the fairy calendar that do not involve some sort of celebration or other.

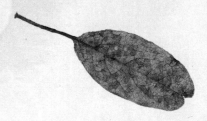

5th Jan 1907. Disaster! "The Regular" came out today with my fairy photograph emblazoned on the first page, accompanied by a long article in which I am not only named as the photographer, but am hailed as an authority on Fairy Lore and cited as a believer in fairies, goblins, gnomes, elves and pixies. I shall become a laughing-stock. I shall never speak to Cousin Nicholas ever again.

Caught such a strange creature today. I do not know what kind of a fairy it could be.

January 1st
Birth of Moonhopper

January 2nd

January 3rd
Icing Morning

January 4th

January 5th

January

January 6th

January 7th
*Celebration of
1st week of
Moonhopper*

7th Jan 1907. A fairy called Findlefick flew in my window and sat on the end of my bed this morning.
"Would you like to take my photograph?" It asked. So I set up my camera and prepared the plates. But the moment I took off the lens cap the beastly little thing made rude gestures at me. I told it that it must sit still — otherwise I could not photograph it. So Findlefick sat still and I got out my book and —

January 8th — SNAP! The vain thing was so busy posing it did not even notice me creeping up behind it..

January 9th
Feast of All Fairies

January 10th
The Fairy Lunch

January

January 11th
Banquet of Fairies, Goblins, Pixies and Elves

January 12th
Goblin Gala
(Fairies not invited)

January 13th
Start of Recuperation Fortnight

13th Jan 1903 · Today is my fifteenth birthday · I am grown-up at last · Mamma and Pappa invited me to have supper with them · It felt very strange · Mamma gave me a toasting fork and a pair of white gloves · Governess gave me a copy of The Household Compendium — an invaluable guide to all householders — and so of little interest to me · Cousin Nicholas gave me a photographic camera ·

January 14th
Moonhopper
(2nd Week)

January 15th

12th Jan 1907. It is as I feared. "The Regular" is full of letters today making fun of my photograph and, of course, of me. It is so humiliating. There were one or two readers, however, who seemed to be impressed and wished to meet me. I shall have nothing to do with them ofcourse.

Got three fairies and two goblins this afternoon! They have never been so easy to catch!

SNAP! SNAP! SQUASH!

I went! It was very exciting!

13th Jan 1907. Cousin Nicholas came this morning and proposed marriage to me! Did you ever hear of such a thing? I told him not to be so ridiculous. He seemed quite upset. I'm sure I don't know why. He knows how I feel about him. How could I tolerate someone who laughs at me behind my back Besides what do I want to have to do with men? They have hair in their ears!

Several newspapermen were round the house this morning pestering me. I shall have to go away. I cannot bear all this. My only consolation is my fairies. Got four today, a goblin, and what I think may be my first pixie!

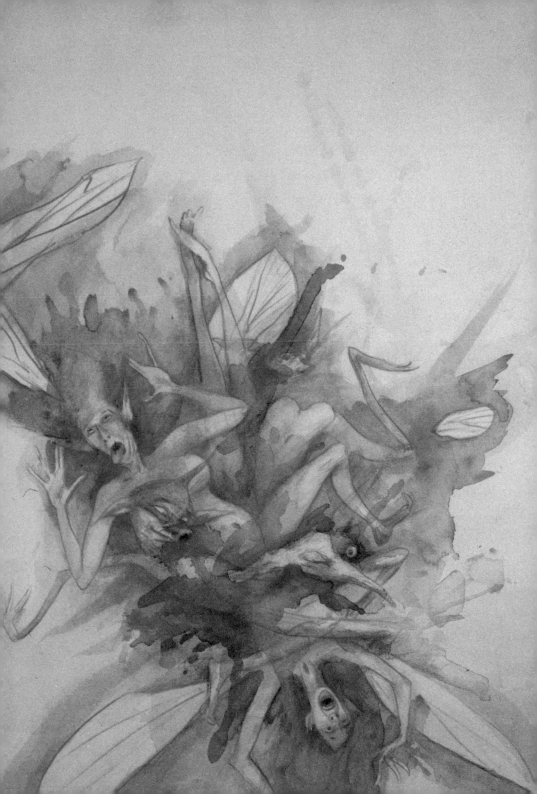

January 16th
Festival of All Fairies

January 17th

January 18th

January 19th

January 20th

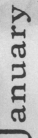

January 21st
*Anniversary of
the Elf Wars*

January 22nd

January 23rd
*Ragwort Dance
(Pixies Only)*

January 24th
*The Fairy-Four
Paganalia*

January 25th

January

January 26th
*End of the
Fifth Quarter
of the Ninth Dozen
of the Thirteenth Set*

January 27th

January 28th

January 29th
Blue and Pink Day

January 30th
Puce and Ochre Day

January

January 31st
Phlegm-Green,
Mouldy-Grey and
Gazzard Day*
(Goblins)

*Gazzard - a colour unknown in the Human World and one which, quite honestly, you wouldn't want to know.

February 1st
Tuppence's Birthday

1st Feb 1903. A big argument with Cousin Nicholas about fairies. He said I was stupid to believe in such rubbish. I said that he would change his tune if I could prove to him that they exist. He said I couldn't. So I went up to the attic to find my flower pressing book. But now I couldn't find that either. It had disappeared — just like my Pressed Fairy Book! I searched the attic through and through but it had just vanished!

February 2nd
Wand Dedication Day

February 3rd
Magnolia and Fish Jubilee

February 4th

February

February 5th

February 6th
*Rubick-Cube-Muddling
Championships*

February 7th

February 8th
*Death of Kelp-Koli
(celebration)*

February 9th
Tales of Kelp-Koli

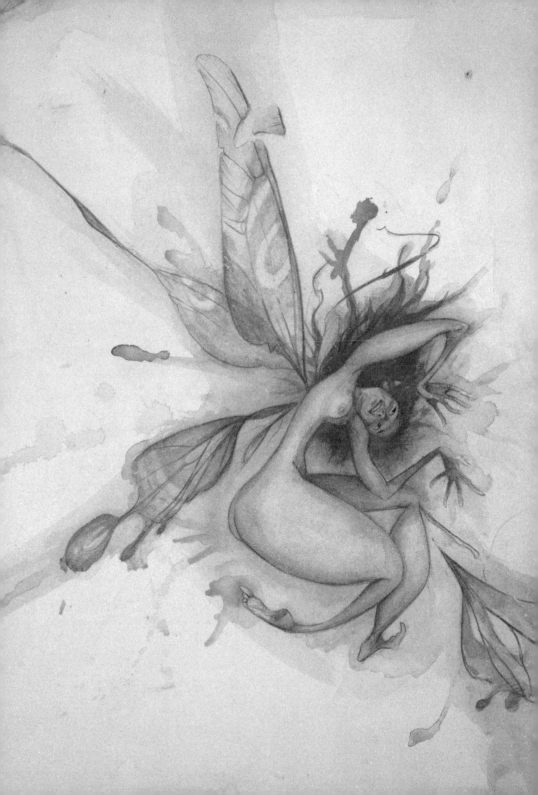

February 10th
Tales of Kelp-Koli

February 11th
Tales of Kelp-Koli

February 12th
Tales of Kelp-Koli

February 13th
Tales of Kelp-Koli

February 14th
Tales of Kelp-Koli

February

February 15th
Tales of Kelp-Koli

February 16th
Respectable Tales
of Kelp-Koli
(5 mins only)

February 17th

February 18th
Fly-By for Fairies and Elves

February 19th
Fly-By for Goblins and others*

February

*Goblins are of course quite unable to fly. However, since the Fairies have a Fly-By Day, the Goblins insist
on having one too: they jump off buildings and out of trees all day long. Casualties are appalling.

February 20th
Adopt a Goblin
Orphan Day

February 21st

February 22nd
Handing-Back of
*Goblin Orphans***

**Goblin orphans are, perhaps, some of the most cantankerous and unlovable creatures in the universe. It is very unwise to adopt one.

February 23rd

23rd Feb 1903. I have finally got the photograph developed. And I can hardly contain my excitement! There on the photograph is the fairy! Now I have proof. Nobody can call me stupid or foolish again — or accuse me of making up stories like my Governess used to do! I can show the world that there really are fairies. Even Cousin Nicholas. But, unfortunately he is away at school again.

February 24th
Giving of Shoes

February

February 25th
Dance of the
Secret Places

February 26th
Dance of the
Known Places

February 27th
The Hop

February 28th

February 29th
Leap Day
(Not every year)

February

March 1st
Elves,
Woodworkers and
Mechanics' Day

1st March 1903. The first person I showed the photograph to was Barker. This was a mistake. He just grinned and said I was a clever little pixie. The stupid dolt of a man. Why did I show it to him?

March 2nd
March Nymphs'
Parade

2nd March 1903. The most unfair fate! My father has taken the photograph of the fairy and locked it in his desk. He says I am not to have it back as long as I persist in my stories. He has also taken away my camera. What am I to do?
I ~~was~~ wrote to Cousin Nicholas.

March 3rd
Marriage of the
March Nymphs

March 4th
March Dryads'
Display

March 5th
Wedding of the
March Dryads

March

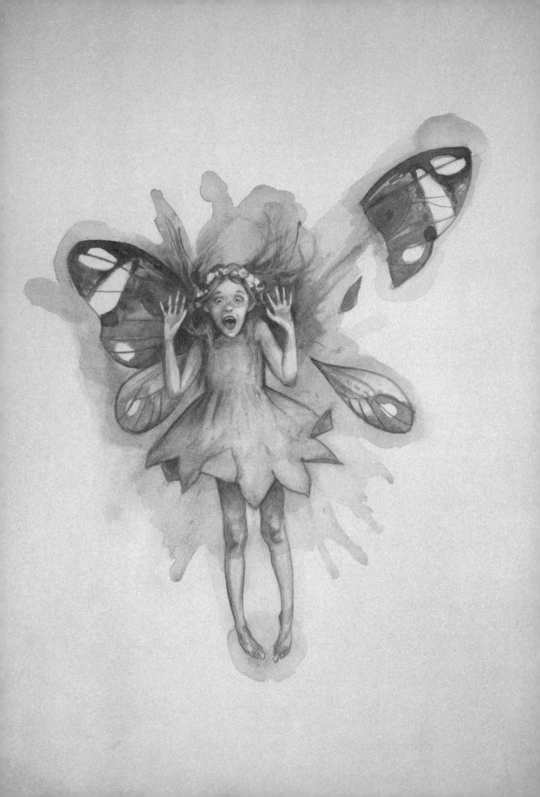

March 7th
Impeachment
of March Goblins

March 8th
Day of No Interest to Fairies

8th March 1903. This morning I received a letter from Cousin Nicholas. He said I should steal the photograph from my father's study and send it to a newspaper. I wrote back that I should not do anything so vulgar.

I fear Cousin Nicholas betrays a coarseness of mind. Perhaps it would be better to have less to do with him in future ...

March 9th
Second Day
of No Interest
to Fairies

March 10th
Whoopsical Day

March

March 11th
Bunching for
Fairies of the
Second Flight

March 12th
Huddling for
Fairies of the
Third Flight

March 13th
Sticking Very
Close Together
for Fairies of
the Fourth and
Fifth Flights

March 14th

March 15th
Dumbstruck Day

March

March 16th
*The Day After
Dumbstruck Day*

March 17th

March 18th
*Sheep and Goats
(Separation) Day*

March 19th
*Zimber-Quattor's
Revenge Week*

March 20th

March

March 21st

March 22nd

March 23rd
Dandelion Dance

March 24th
*Left-of-Field
Fanciers'
Fortnight*

March 25th
*Numbskulls and
Clodhoppers'
Dance*

March

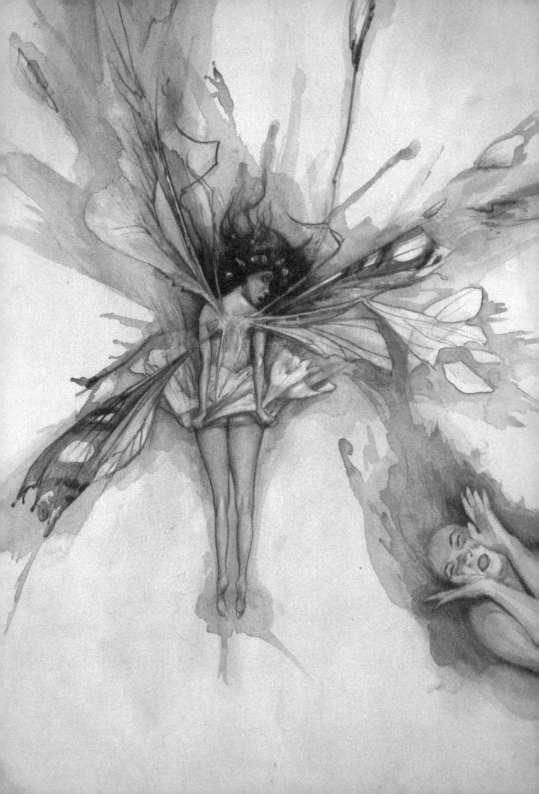

March 26th

*End of Zimber-Quattor's
Revenge Week and
Day of Reconciliation
With All Those
Whose Hats Have
Been Damaged*

March 27th

March 28th

*Invasion of
Loaming Shores
Beyond the
Certain Sea
Anniversary*

March 29th

A Day of Redress

March 30th

*Fairies of the First
Wand Reunion Dinner
(Guests not invited)*

March

March 31st
*The Day Everyone
says "31" a Lot*

April 1st
*The Cruellest
Month Week*

April 2nd
*Spring Fever
Medical
Aid Appeal*

April 3rd
The Shower Dance

April 4th

April

April 5th
Fringe Fairies'
Welcome Party

April 6th
"Sorting-Out
of the Doggets" Day

1st May 1907. Napoli, Italy. I have escaped! It is beautiful. But even here I am surrounded by my fairy friends. This one came and hovered over my bed. I keep my book under the bedclothes and was able to surprise it.

April 7th

April 8th
Invocation
of Lumps
and Cysts
(Goblin celebration)

April 9th
Verruca Day
(Goblins again)

April

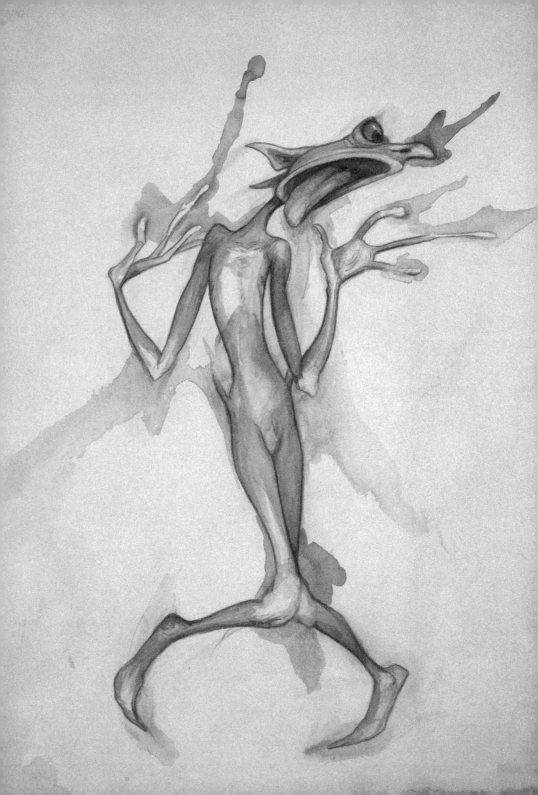

April 10th

April 11th

April 12th

April 13th
Squashing of
Moonhopper Day

April 14th
Elfin Choirs
Congress

April

April 15th

April 16th
*Day of Mushroom
Encouragement*

April 17th
*Nimble Fairies'
Scattering*

April 18th

April 19th
*Bandages and
Lozenge-Sucking
Competition**

* Bandage-Sucking is now banned (and, if you've ever sucked a bandage, you'd know why) but Lozenge-
Sucking is still permitted and, indeed, encouraged for those fairies with coughs and sneezes.

April 20th
*Anniversary of
Something That
Happened So Long
Ago Everyone
Has Forgotten
What It Was*

April 21st
*Homecoming of
Elves (Singing)*

April 22nd

April 23rd
Chance Day

April 24th
*Happenstance and
Coincidence Evening*

April

April 25th

April 26th
*Fairy Laughter
Convention*

April 27th
Furze-Hopping Event

April 28th
*Chicken-Tickling Day
(Leprechauns)*

April 29th
*Milk-Curdling
Sunday
(Gremlins)*

April

April 30th
Fairy Queen's Birthday
(Netherlands)

May 1st
Faint-Hearted
Fairies May
(Or May Not) Ball

May 2nd
Door-Banging and
Window-Tapping
Conference
(Gremlins)

May 3rd
Bent Wand-
Straightening Day

May 4th
Fairy Ring Day
(Giving)

May

May 5th
Fairy Ring Day
(Receiving)

May 6th
The Sixth Day of May

May 7th

May 8th
Dog-Prodding
(Gremlins)

May 9th
Royal Society for the
Prevention of
Cruelty to
Fairies Founded

May

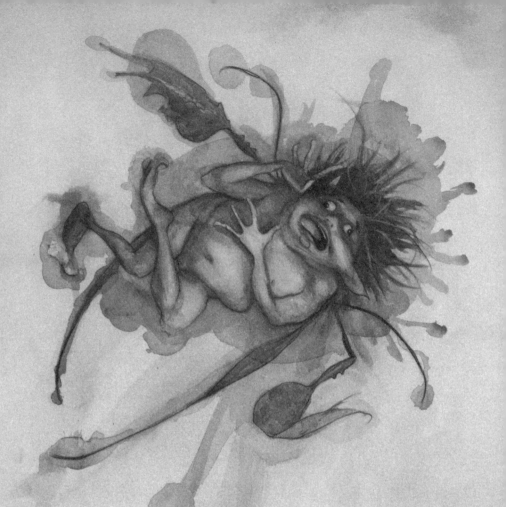

2nd May 1907. Lord Crowley asked for my hand in marriage this morning.
Such arrogance! We only met two months ago, and I scarcely think I
have formed any attachment to him — nor, indeed, do I imagine that he
could, that I had! And yet there he was on his knees trying to grasp
my hand in his. The most terrible shudder of revulsion ran through my
veins as I remembered that book so long ago, and I imagined the depictions
within it of men and women caressing in the most lewd and abandoned
manner — and then I thought of myself and this gross man in similar
contact ... oh my blood runs cold just to think of it! Lord Crowley has
more hair in his ears than anyone I know.

My fairy collection grows every day! But I am not at all sure
that these Italian fairies are quite proper. They seem to have a leering
quality about them that I do not at all like.

10th May 1907. More Italian fairies. They seem to be almost showing off. I am not sure I like them.

15th May 1907. I do not know when I have been so vexed and horrified. I had been feeling rather unwell, and retired to my bed early, when I heard a knock on the door. My chambermaid opened it and announced Lord Crowley wished to speak to me. I was about to say no, when in he walked bold as brass. To my horror Mathilda withdrew at the same moment, saying she had some pressing business downstairs. "Mathilda!" I shouted. But the hussey was gone — leaving me alone in my bedroom with a man! What should I have done?

At this moment my astonishment was completed by the appearance of a cuple of fairies, hovering in the air just behind Lord Crowley's shoulder. I confess, that at their appearance I must have smiled, for they certainly looked properly comic. Thus the damage was done! Lord Crowley took my smile as a hint of encouragement, and in no time, he had sprung to my bedside and seized me in his arms crying: "My darling! I knew you wanted me to come!"

Imagine my indignation and despair. As I felt his moustachios covering my mouth, I almost choked, and then as I gasped for air, I caught sight of the most ludicrous display. The two fairies were performing a rediculous pantomime of his Lordship behind his back. One of them was pretending to be me and the other Lord Crowley — complete with vast whiskers made from the cats' tail. Unawares of all this, Lord Crowley pressed me to his breast and a gasp of laughter escaped me. This the stupid man took as further encouragement! "Yes! Yes!" he cried. "Your happiness is my happiness!" Oh misery! Before I knew what was happening, he had buried his face in my nightdress and was trying to put his disgusting hands upon my body!

I will not go into further details of this most unhappy night. Suffice it to say that those wicked fairies flew around me, tickling me and touching me with their wicked little hands so that I cried out with laughter, or gasped for breath on more than one occassion thus fuelling His Lordship in his mistaken impression that I was encouraging him!

Indeed, every time I raised my hands to strike the beastly fellow or to push him away from me, one or other of those naughty fairy folk would tickle me under the arms so that I shrieked with laughter and pulled my arms back. Whereupon His Lordship kept shouting: "That's it! Give me the rein! Saddle her up! Now the water jump! and so forth. The man was clearly quite out of his mind.

How long this ordeal continued, I am not sure. But I grew weak and trembling with my exertions and one of those impudent fairies seemed to be right inside me — tickling me from within so that I could scarce think and scarce knew what was going on.

When I came to myself, I was lying alone in my bed. To my infinite relief, His Lordship had gone, but the two fairies were sitting on the end of my bed. They were grinning, though they looked dischevelled.

"Go away!" I shouted at them. But they just turned around and bared their bottoms at me! Whereupon I seized up my book and BLATT! I got them both in one smack. Serve them right. Though it is so indecent a picture that I can now scarcely look into my own precious book, let alone invite others to gaze upon it!

May 10th

May 11th
Fairy Society for the
Prevention of
Cruelty to Royal
Humans Founded

May 12th
Fairy Society for the
Prevention of
Cruelty to Royal
Humans Disbanded

May 13th
Fairy King and
Queen Jumping
Competition

May 14th
French Fairy
Awareness Day

May

May 15th
French Fried Fairy
Awareness Day

May 16th
Falling Off a Log Night

16th May 1907. Stayed in my bed all day.

May 17th

May 18th
Moonbeam-Hopping Gala

May 19th
Dance to mark
the Third of January.*

May

*The Third of January is an important day in the Fairy Calendar, as it was the day when the first fairies (the Founding Fairy Fathers) arrived in what is now called Fairyland. Nobody knows where it was they lived before that, and nobody knows why the third of January is celebrated on the nineteenth of May.

18th May 1907. I begin to wonder whether the fairies are taking their revenge upon me. The one thing I am certain of is that last night was all their fault. After my careful instructions nothing went according to plan. Mathilda apparently took some sleeping drug and remained in her own room fast asleep, where I was unable to rouse her. I did indeed think of sleeping the night in her bed, but the thought that I could at least lock the door encouraged me to return to my own bedroom. There I carefully turned the key in the lock and placed the key upon the mantlepiece.

About half an hour later, I heard a little scrabbling noise, and tip-toeing over to the door, I saw a little gremlin creature wriggling out of the keyhole. It jumped down onto the carpet and performed a rude little dance in front of me. "Go away!" I cried more than once. But the little thing suddenly shrank itself down so I could hardly see it and then leapt towards my face!

At the same time, I heard a tap on the door. "Mathilda?" I whispered. But the door opened and in slipped none other than... Lord Crowley!

I tried to exclaim: "Lord Crowley! There has been a dreadful mistake!" But to my dismay I found that the little gremlin had jumped into my mouth and was now holding my tongue and twisting it this way and that against my will, so that what I said sounded more like: "Lord Crowley! I could hardly wait!"

I will draw a veil over what happened, but as soon as Lord Crowley was gone I made sure that I got that beastly little gremlin. Here he is.

I also decided that I must leave Italy on the first available boat.

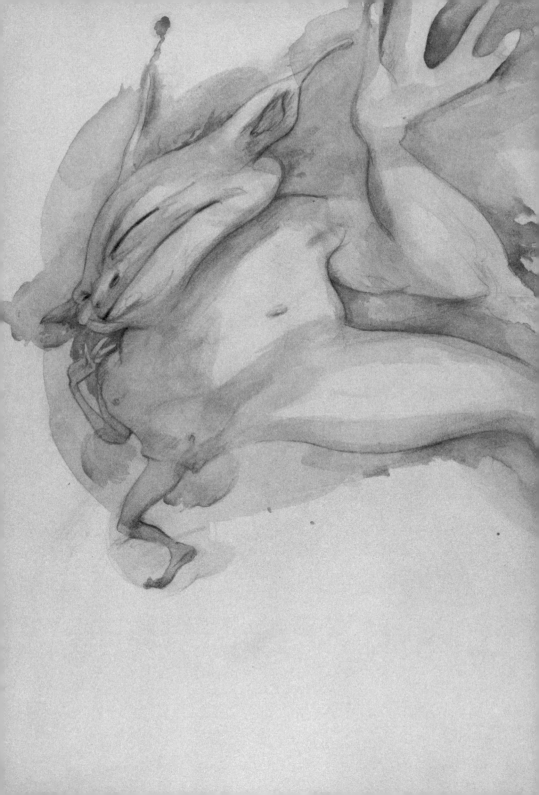

May 20th
The Dainty-Four
Remembrance Day

May 21st

May 22nd
Toad-Pinching
(Pixies)

May 23rd
Bluebell Day

May 24th
Day for the Naming
of Rocks and Planets

May

May 25th

May 26th
Goblin Races

May 27th
*FindleFritter's
Stoat-Wheedling
Event*

May 28th
*Day of the
Pin-Hiding and
Button-Losing*

May 29th

May

May 30th
This Day

May 31st
This Day
(again)

June 1st
Hen-Peelers' Holiday

June 2nd
Festival of Light
and Dark Spots

June 3rd
The Worst Day in
*the Fairy Year**

*No one quite knows why this day has been so named. One theory is that this is the day on which King Gargle-Afterwards first launched his drive to prevent fairies from drinking nectar whilst under the influence of Moonshire. Others say it is more likely to have been named after the day on which Queen FlatBirdHat invented the digital wristwatch.

June 4th

June 5th
Judgement Day
(Nosegays)

June 6th
Judgement Day
(Petal Hat)

June 7th
Judgement Day
(Leaping Songs)

June 8th
Judgement Day
(The Good and the
Evil are given their
just rewards)

June

June 9th

June 10th
*Holiday of the Wan Thing***

**The Wan Thing arrived in Fairyland on this day and simply stayed there looking wan ever after. Fairies feel sorry for the Wan Thing, but never try to help it.

June 11th
*Holiday of the Happy Gnomes****

***A very under-subscribed holiday as most gnomes have a less-than-sunny disposition.

June 12th

June 13th
*First-in-Line and
Queue-Jumping
Tournament*

June

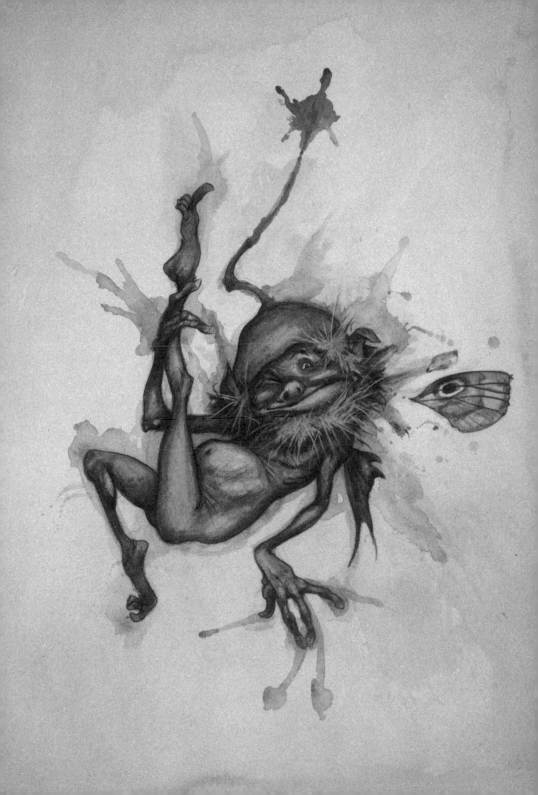

June 14th

June 15th
*The Day of
Third-Hand
Reports and
Shaky Evidence*

June 16th
*Rumour Sunday
(usually a weekday)*

June 17th
*Toadstool-Squatting
Begins (Leprechauns)*

June 18th
*Tiger-Get-By's
Birthday*

June

June 19th
Tiger-Get-By's
Second Birthday

June 20th
Festival of
the New Knee

June 21st
Tiger-Get-By's
Third Birthday

June 22nd
Elfin Music Festival

June 23rd
Dandruff Dance
(Goblins and Gnomes)

June

June 24th
Lost Handkerchief Week

June 25th
Elf Thumping Day

June 26th
*Handing Back
of Tiger-Get-By's
Presents*

June 27th

June 28th
*Thanksgiving
for Useful Fairies*

June

June 29th
Wicked Fairies
Summer Debate

June 30th
Crab Races
(Pixies, Elves and
some Fairies)

June 31st
A Day That Doesn't Exist

July 1st
Distressed
Elves' Day

July 2nd
Distressed Elves'
Creditors' Day

July

July 6th 1895 · Nanna wuldnt bleive me · Ettie wuldnt bleive me · Auntie Mercy wuldnt ~~bl~~ bleive me · But i got one · Now they've got to bleive me ·

July 7th 1895 · I showd my ~~frai~~ faerey to Ettie but she ~~s~~ sed Nanna wuld be cross · bekaws my book is for pressing flowers in not faereys so i wont show it to anybody I am going to fill my Book up with faereys so their ⋰

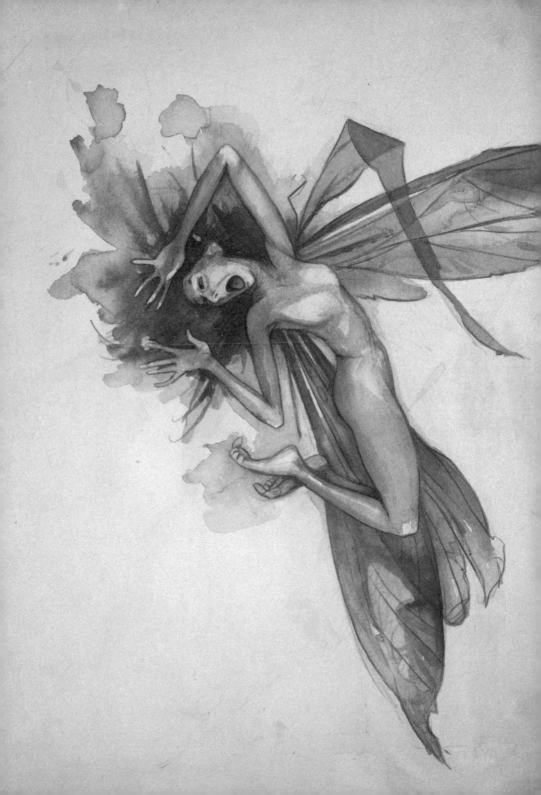

July 3rd
*Distressed Elves
Creditors' Pets' Day*

July 4th
*Jumping on the
Mattress Night*

July 5th

July 6th
Millennial Fairy Olympics

July 7th
Millennial Fairy Olympics

July

July 8th 1895 · I cort another faerey. It was flying passed my window but i was too quick for it it didn't see me cuming up behind it But i only cort a bit of it.

July 8th
Millennial Fairy Olympics

July 9th
Millennial Fairy Olympics

July 10th
Millennial Fairy Olympics

July 11th
Millennial Fairy Olympics

July 12th
Millennial Fairy Olympics

July

July 13th
Millennial Fairy Olympics

July 14th
*Festival of Millennial
Fairy Olympics*

July 15th
*Petal-Hopping
for Beginners*

July 16th
*Petal-Hopping
for Non-Starters*

July 17th
*Petal-Hopping
for Hopeless Cases*

July

July 15th 1902. I have been thinking that perhaps the fairies have been avoiding me, for I certainly have seen neither wing nor wand of them for some years. Sometimes I open my book of pressed fairies and I can hardly believe what I am looking at. Did I really see these creatures flying around my head? Did I really catch them in my book? Where have they gone? Have I lost the ability to see them forever?

Many times I have gone down to the potting-shed and sat there still as still and yet I have seen nothing.

Sometimes I have felt fairies around me – but nothing more.

But today something amazing happened.

I was down behind the potting-shed, when I spotted a little window I had never noticed before. I looked through it and could hardly believe my eyes! The inside of the potting-shed looked quite different through that window. It was all neat and tidy, and there was a little scrap of rug, and two chairs and a strange black stove – in fact just like I'd always longed to have it.

I squeezed through the little window and into the potting-shed. A fire was burning in the stove. How strange! The potting-shed was usually full of broken pots and dead tomatoes, and a few old wooden boxes full of soil. But now there was a kitchen dresser against the wall, and a book on the shelf.

I was just going to look at the book, when the kettle on the stove started to whistle. So instead I took it off the stove and filled the teapot that suddenly appeared on the table. Then a cup appeared and a jug of milk. "I suppose I might as well have a cup of tea," I said to myself. But it was the strangest tasting tea I ever did drink, and afterwards I felt quite drowsy … In fact I think I must have sat in that cosy chair and fallen asleep, for the next minute it was dark.

There was a candle burning on the dresser. When I went across to it I saw that the book was now open. So I picked it up and read what was written on the page. It said:

"The Fairy Call
A spell for summoning the fairies.

Sit where the cat sits. Cross your toes.
Close your eyes. And smell a rose.
"I Then say under your breath:
believe in fairies, sure as death."

Gadflykins! Gladtrypins!
Gutterpuss and Cass!
Come to me fairily
Each lad and lass!"

Just at that moment, I heard my Governess calling from the house, and I knew I was in trouble. I rushed to the door of the potting-shed and tried to open it. But it seemed to be locked, which is odd, because the potting-shed door is never locked. And when I peered through the keyhole I saw... Dear Diary, I cannot even tell you what I saw! It was... perhaps one day I will write it down, but just now I can't...

I climbed out of the window, but unluckily I dropped the book back inside as I was jumping out. "I'll get it tomorrow," I thought, and ran up to the house. She really was very angry with me. She thought I had run away, because it was so late and I had been gone so long. I didn't get any supper.

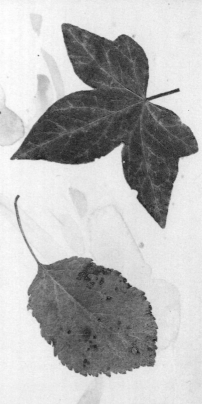

July 16th 1902. This morning, as soon as ever I had finished my lessons, I ran down to the potting-shed, but there was a mystery. I could not find the little window through which I'd climbed only yesterday. It was quite quite vanished- as if it had never been. I almost cried. But I said to myself: "Come come! This will never do! Sir Walter would never have sat down and cried!" Then it suddenly occurred to me that I could remember the spell-clear as daylight!

So I fetched my Pressed Fairy Book and my chair and sat behind the shed and said the spell. I sat and waited and waited, but nothing happened. Then I realised I was doing it all wrong. I had to do what the spell said. I had to sit where the cat sits and smell a rose and all that.

The cat sits in the aubrietia. So I got a rose, sat amongst the aubrietia and shut my eyes. Before you could say Simpkin-Spilikins, I heard tiny sounds like sugar cubes falling in a well, and tiny laughter and music no louder than a mouse's breath. I opened my eyes and there all around me on the grass and in the air were the fairies. They had returned to me after all these years.

This is the one I got this time. She is a funny little thing. I think her name must be Mothcatcher. She is a little lop-sided creature. No doubt she casts spells on chickens and on the legs of dogs. It is she who turns biscuits soggy when you dip them in your cocoa for only a second, and it is she who makes those mysterious holes that appear in your pinafore, when your Governess had it darned only the other day. I think she looks rather nervous.

July 18th
The Lunch of the Forward Goblins
(surprisingly : Fairies only)

July 18th 1902 · The fairies didn't come yesterday. But they came today, and I caught two! One of them is called Mogcracker and the other Skamperdans. They are both mischief-makers and like getting girls into trouble. Mogcracker will take the lessons that you finished last night and got all the sums right, and make them all wrong by the morning. She gets your essays and puts all the spelling out, when you'd spelt it perfectly correctly.

July 19th
Back-to-Front Yad

July 20th
Thgir-yaw-Dnuor Day

July 21st
Touch Hammer's
Birthday Bargain Day

July 22nd

July

July 23rd

July 24th
Jilwalla Jinks'
Jamboree

July 25th
The Festival of
the Knee-Knockers

July 26th
Wonderful Drinks Day

July 27th
Over-the-Moon Night
(Cows and Spoons)

July

July 28th
*Imp-Handling
Conference*

July 29th

July 30th
Herbal Ballooning

July 31st

August 1st
Imps Charity Scramble

July

August 2nd
Distribution of
Charity Moneys
(Strictly Imps only)

August 3rd
Fairy Washing Festival

August 4th
Fairy Drying-Out Day

August 5th
Pixie-of-the-Year
Competition

August 6th
Best Elf Awards

August

August 7th
*Smartest
Leprechaun
Eisteddfod*

August 8th
Finest Fairy Finals

Aug 8th 1899. It has been three years since I last saw a ~~fairy~~ fairy. I was beginning to think I would ~~never~~ never see one again. But I was down by the potting shed and suddenly I saw one. I crept up behind it and opened my book and SMACK! I caught it! Its a funny looking one. I think it must be a goblin or a elf.

August 9th
Goblin Ugly Contest

August 10th
Day of Wandering

Aug 10th 1896. I new ther was faereys behind the pottingshed so i went and sat very still with my book open in my lap and the faereys was curius and tings inkwizitf and they all came round to look at me and one landed on my book and i went SNAP! I banged the book shut and i cort the faerey it is a reelly Bewtiful one. I like it best.

August 11th

Aug 11th 1899. A great many faeries came buzzing round me todday. They seemed quite ~~extra~~ excited and kept glaring at me and flying right up my nose. But I still caught one. I am going to call her Florizal. She is an young fairy who was a little bit more daring than the rest. I wonder what she did in Fairy Land, and how old she was? Perhaps she was ten years old – perhaps thirty – perhaps thirty thousand. It's hard to know what is old with fairies.

Here is the Story of Florizal The Nosey Fairy..

There is nothing she would not stick her nose into. If you left the milk out at night – as like as not, you'd find Florizal floating in it in the morning.

"Help me out," she would say, "for the sides of this jug are too steep and slippery and my wings are all soggy with milk."

"Will you grant me three wishes if I do?" said the little girl.

"I can't do three wishes," replied Florizal, "because I left my wand behind, but I can grant one."

"That will do," said the ~~little~~ little girl, and she put a straw into the milk and the fairy climbed up it. Then the little girl gave Florizal a wash in her own wash basin. She made a shower with a tea strainer and Florizal washed all the milk out of her wings and rule-book. (Fairies always carry a rule book with them – especially if they are only apprentice fairies like Florizal.) Then the little girl sat the fairy in front of the fire and dried her off. And all the time Florizal kept asking: "What's that burning in the grate? Where do you keep your magic powder? How do you fly anywhere? What's the name of your king? Who do you look like? Why do you go to bed at night?" and so on and so forth. And the little girl tried to answer her as best she could.

Then when she had quite dried the fairy and her wings were ~~all~~ all shimmering a ready to fly, the little girl said to Florizal:

"Now can I have my wish?"

"Oh!" said Florizal, "I said I could grant one wish, but never said it was your wish! It's my wish! And I wish I was out of here!" And she disappeared – like a bubble bursts – ~~and~~ and all that was left of Florizal The Nosey Fairy was a little wet patch on the rug.

For I forgot to tell you – Florizal was not only a nosey fairy she was also a very tricksy one as well.

The End.

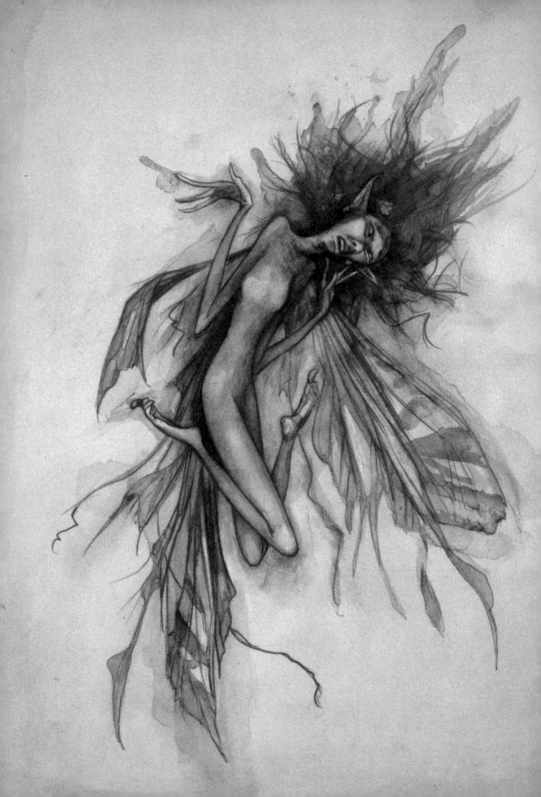

August 12th
Anniversary of
Snick-Snacker's
Left Foot

August 13th
Anniversary of
Snick-Snacker's
Right Foot

August 14th
Anniversary of
Snick-Snacker's
*Deerk Foot**

*Fairies have not only a left and right foot but also a ``deerk'', for which humans have no equivalent orientation.

August 15th
Watch-the-Pot
Week (begins)

August 16th

August

August 17th

August 18th
Toge-Pogling
Season Begins **

**Toges are normally pogled in groups of five or six. The extent to which they are pogled is, naturally, dependent on the size and strength of the individual Toge.

August 19th

August 20th

August 21st
Watch-the-Pot
Wednesday

August

August 22nd
Boil-Over
Thursday

Aug 22nd 1902. A terrible shock today! I found Auntie Mercy rummaging around behind the big steamer trunk in the attic. That's where I hide this book. It's the only safe place in the house because generally no one goes up there except Ettie and me and sometimes Cousin Nicholas, but he doesn't count because he's a boy and doesn't believe in anything.

August 23rd

August 24th
Rumpleskunkskin's
Wedding
(Goblin Celebration)

August 25th
Rumpleskunkskin's
Bride Escapes to
Heerwigoland
(Fairy Celebration)

August 26th
The First Thnork
of the Year

August

August 27th

August 28th
*The Threethousandth
Thnork of the Year*

August 29th
Day of Loose Talk

August 30th
*Chatter Champion
Announced*

August 31st

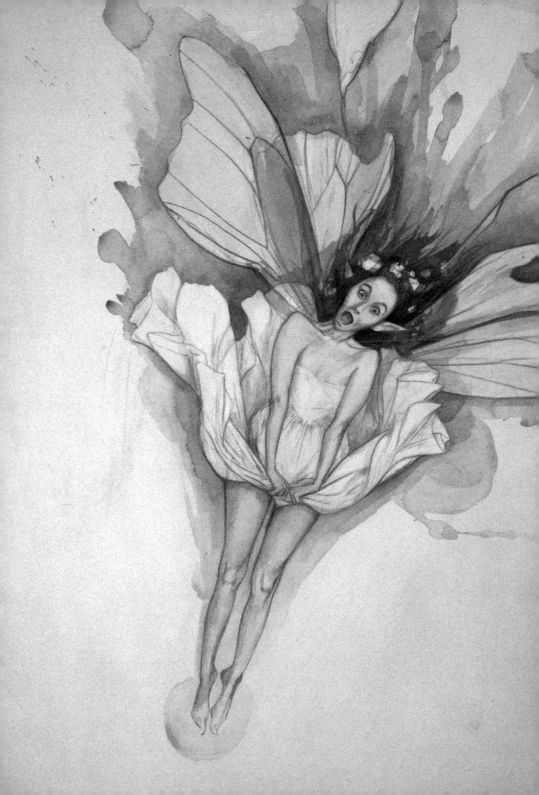

3rd Sept 1907. Framlingham. I am so relieved to be free of those wretched Italian fairies. I can still scarcely credit the trouble and wickedness into which they led me. Now I am back and will be surrounded only by good English fairies: woodland nymphs and sprites and dryads. I feel the air is cleaner and sweeter already. Ah! The peaceful lanes, the green hills and the still woods! I will dedicate myself to my collection of Pressed Fairies, and forget about the horrors of my continental sojourn.

Or so I thought this morning as I stepped into the garden of the old house for the first time since my return. But I was to discover that "Italian ways" seem to have affected the fairies even in England. Oh! How can I go on collecting them? And yet how can I stop? Pressing my fairies has become such a part of my life, that I fear, were I to stop, my existence would have no more meaning. What am I saying. Perhaps I am going mad?

I was sitting in the arbour, upon the stone bench, when I heard a rustle behind me. I turned to find several fairies all dressed-up as if for a ball.
"Where are you lot going?" I asked them bold as brass.
"Wouldn't you like to know," said the first – a shameless little creature in a high laced-up bodice.
"We're dancing a Dainty-Four," said another. "Do you want to join us?"
Dear Diary, I should have known it was wrong, but what could I do? The fairies had never before invited me to be one of their number. I could hardly believe my good fortune – or what I thought was my good fortune. Of course, I was soon to realise my mistake, but it is all very well to be wise after the event.
"Yes," I replied, "I should like to very much."
"Then take this," said the fairy who wore a ring in her nose. She handed me a buttercup that was full to the brim of some potion.
"What is it?" I asked warily.
"Try it," said the fairy.
It was almost as if I were already under their spell. Even as I told myself I would regret it, I took a sip from the buttercup, and the sweetest nectar slipped around and over my tongue like a liquid glove of exquisite pleasure or pain – I could not be sure which.
"Now you are the right size," said the fairy in the hat, and sure enough, I found I was no bigger than any of them.
"So you can dance the Dainty-Four with us," said Rumbleskamps – the fairy with the ring in her nose.

September 1st
Sneeze-Wobbling Festival

September 2nd
*Coughing and
Spluttering Convention*

September 3rd
*Day of Universal Alarm**

*No one is quite sure what anyone else is alarmed about on this day - and that's what makes it so alarming.

September 4th

September 5th
*Wag and Carrot
Fancying Day*

September

September 6th
Ear and Trumpet
Contests for Mice

September 7th
Welsh Fairies
Bonnet-Hurling
Competition

September 8th

September 9th
Milk-Bathing
Festival

September 10th
Harvest Home
Nibbling Contest
(Gremlins)

September

September 11th

September 12th
Discontinued
Thought
Exhibition

12th Sept 1907. What am I to do? My fairy tormentors will not let me
be. For I realise now, that they are tormenting me. It is deliberate. I
am sure of that.

 Even lying in my bed they sometimes tip-toe around me. They think
I cannot see them. But I do. I open one eye just a crack and I see
Dewsletter or Grim Thumb or Cymbal Turnip ... (For I am grown so familiar
with them nowadays, I even know their names) ... as they creep across my
covers, giggling and nudging each other. The odious little pests. Why wont they
leave me alone?

September 13th

September 14th
Unclear Ideas
Display
(Imps)

September 15th
Really Bad Ideas
Exhibition
(Gremlins)

September

September 16th

September 17th
*The Return of
Kelp-Koli
Celebration
(under duress)*

September 18th
Ear Wig Fitting Day

September 19th
*Jubilee of the
Moth Moons*

September 20th

September

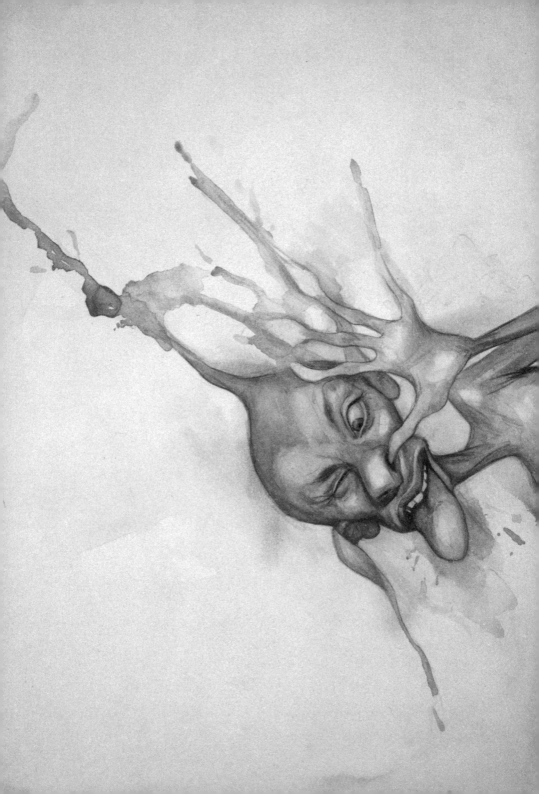

September 21st
*Breakfast, Dinner
and Supper Day
(Goblins)*

September 22nd
*Breakfast, Snack, Elevenses,
Snack, Lunch, Snack, Tea,
Snack, Dinner, Snack,
More Snacks, Supper,
Snack and Bilgewack Day (Borms)***

**Borms are a little-known relative of Goblins. They tend to obesity and generally do very little other than sit around and eat and feel ill. This is probably why the human world has had so little contact with them. "Bilgewack" is a Bormish term for Having Probably Eaten Too Much and Needing to Lie Down.

September 23rd
Bunster Winding

September 24th

September 25th
Toad Tempting Day

September

September 26th
Cobweb Pie Making

September 27th
*Thanksgiving Day for
Disappearance of
Kelp-Koli again*

September 28th
*Tales of Kelp-Koli`s
Second Visit*

September 29th
*Tales of Kelp-Koli`s
Second Visit*

September 30th
*Tales of Kelp-Koli`s
Second Visit*

September

13th Oct 1909 Today I spoke with the Bishop. I had decided to do this a month ago, and this morning when he called, I resolved to take the plunge. I cannot tell you how fearful I was, and yet I felt there was no other help for me against the Fairies.

The Bishop was, of course, familiar with the photograph that had appeared in "The Regular" two years ago, but how was I to tell him of the things that had happened since? Or of the doubts that had assailed me in recent years? Still, since the mysterious death of my parents two years ago, he has been my spiritual adviser, and I took courage from the fact that he was a learned man and a sympathetic friend. Or so I thought.

We were seated in the morning room beside a small fire. The sunlight swept in through the window and dazzled me somewhat, so that I could not clearly see the Bishop's face. However, I had resolved to tell my story and I am not the sort of person to be put off once I have come to a decision.

"Your Grace," I began. "I feel I can confide in you as my oldest and most trusted friend."

"My dear Lady Angelica," he replied. "No-one could have your best interests more closely bound to their heart."

I shut my eyes and took a deep breath. This was the moment. I had this book — my book of Pressed Fairies — upon my lap and it gave me confidence to feel its familiar edges and smell the slight perfumed fragrance that exuded from its pages and that seemed to strengthen as my collection grew. It was time I spoke out, and for the first time since I had spoken to that wretched Cousin Nicholas, I would reveal to someone my long-held secret.

In the sun-beams I thought, for a fleeting instant, that I saw Moon Hopper fondling her breasts close to his Grace's ear, but as I looked again all I could see was dust in the air.

"Your Grace," I began again, "since I was a small child..."

And so I told him of my first experiences with the Fairies. I told him of Florizal, the Nosey Fairy, of the Fairy Call, of the Mischief-makers. I told him about Auntie Mercy and the disappearance of my precious book, of Pipkintinkle and Tuppence, of the way the Fairies seemed to grow bolder and seemed to provoke me in to pressing them. I then carefully broached the subject of the Italian fairies, and the shameful way in which they behaved towards me at the Villa Carnale, and I was just leading on to the distressing way in which they have tormented me ever since my return to England, when to my utter surprise I found his Grace seizing my hand in his and

whispering to me in an urgent voice:

"Oh! Lady Angelica! Yes! They torment me too! Those little fairies!"

Upon my faith, I do believe the man had taken leave of his senses! I moved out of the sunlight in order to be able to see him properly. His eyes had an unnerving intensity about them and he seemed to have dribbled on his purple front. At the same time he slipped his arms around my waist.

"Oh Lady Angelica!" he was mumbling. "It's only natural! Let yourself go! Follow the fairies! You are so beautiful! So damned beautiful! Yes! They torment me too!"

My book of Pressed Fairies fell to the floor. I tried to beat him off, but it is difficult to strike one's spiritual adviser – particularly when he is the Bishop of Stoke and Cherwell.

"There is only one way to defeat the fairies!" he sounded more as if he were moaning than talking. "Give in! Do what they urge you to!" And His Grace suddenly put his tongue into my mouth!

I do not know which surprised me the most – the fact of suddenly having someone else's tongue in my mouth or the fact that it was a tongue that hitherto I had only glimpsed in the course of delivering sermons on the denial of the flesh and the pleasures of abstinence.

"Your Grace!" I managed to say, but he was already fumbling with my corsage.

"Those fairies! They lead me a merry dance I can tell you! Ah! Your breasts are whiter than a five-pound note!"

October 1st
Flattering Finals

October 2nd
Buttering-Up
Quarter-Finals

October 3rd
Buttering-Up
Semi-Finals

October 4th
Buttering-Up Final

October 5th
Festival of the
Five Toes

October

October 6th
*Festival of the
Other Five Toes*

October 7th
*Festival of
the Deerk Toes**

**See August*

October 8th

October 9th
Curious Events Holiday

October 10th
*Celebration of the
Squeezed Nipple*

October

October 11th
*Cloud-Stamping
Pentathalon*

October 12th

October 13th
Sunbeam Sliding Sunday

October 14th
*First Fiddle
of the Month*

October 15th
Rainbow Pickling Day

October

October 16th

October 17th
*Large Fairies
Come First Day*

October 18th
*King Look Under
Your Mattress's
Unique Hiding
Display*

October 19th
Seek the King Week

October 20th
Seek the King Week

October

October 21st
Seek the King Week

October 22nd
Seek the King Week

October 23rd
*The finding of the
King Jubilation*

October 24th

October 25th
*Munzipan Feast***

October

**Munzipan is a favourite delicacy amongst fairies of all kinds. It is made from everything edible mixed
together and put into a certain goblin's ears. The mixture is then left in his ears for the best part of the year
and then scraped out on the day before the Munzipan Feast. Why fairies like it is a mystery.

October 26th
Toping Wagglegammon ***

***The significance of this is not entirely clear.

October 27th
*Tunch Paddling
Festival* ****

****Paddling Tunches is rather similar to throwing bits of twig into a pond. Prizes are given for the most
artistically selected twigs and for throwing style, etc.

October 28th

October 29th
*Second Fiddle of
the Month* *****

*****A very unattended occasion, since no one likes to play second fiddle.

October 30th

October

Nov 23rd 1903. Today Auntie Mercy died. We were all upstairs crying and she died in her room about 3 o'clock. The Doctor said it was very peaceful.

It is a curious thing but today I also found - at long long last - my Pressed Fairy Book. It was perfectly safe and not damaged in any way. But the most curious thing was where I found it. It was behind the steamer trunk in the attic where I had always kept it. And yet I had looked there time and time again and it had not been there.

But the strangest thing was that there were several new fairies pressed in the book! Who ~~has~~ had done it? Certainly not Auntie Mercy. I had told no one about it. I cannot understand it. Perhaps the fairies themselves did it? But why would they press their own kind?

I opened these pages with trembling hands. And now I have a terrible confession to make. As I looked at the familiar faces of my fairies I was suddenly overwhelmed with remorse. As I thought of these dear little creatures and I imagined the end to which I had brought them, I suddenly felt a strong sensation of guilt sweep over me, and I went red as the hearth rug. How could I have done this? Surely I was the cause of much pain and anguish to these dear little things that I loved so much! Why had it never occurred to me before? Was I just a heartless little girl with no feelings?

My mind was thus in a state of such perturbation, that I know not how long I had been sitting there, when suddenly - to my astonishment - I saw a little figure hovering in the air but a few inches from the book which lay upon my lap.

And then my astonishment was complete, when the fairy spoke to me.

"Top of the dew!" it said. "My name is Tuppence. And I have come to test you on your Latin irregular verbs!"

At this, it landed on the open pages of my book, and …I don't know why, nor can I now offer any defence for what I did …but it was as if the old habit were too strong. I simply could not help myself. The moment its little feet alighted on the page I banged the book shut on it and I heard the familiar little shriek and the slight squashing sound as I pressed the book shut harder and harder.

Then it all went quiet. I looked around the room. Everything was perfectly normal. The clock was ticking on the shelf above the ottoman. My old nightgown was thrown across the back of the chair just where I had been told not to leave it. The fire in the grate crackled and fizzed with new wood. And yet I felt like a murderess. I thought my hands were stained with blood. They looked red - and yet I knew that it was my fancy, for fairy blood is never red. For a moment I thought I could hear other fairies around me. Perhaps they will seek retribution! Perhaps they will try to get their own back on me.?

'For the
first time I felt
afraid. I felt uncertain
of this whole mysterious
world into which I have
had such glimpses. And
yet... if I could hear
anything... it was tiny cheers!
Impossible!
 I put the book down and
backed away to the other side
of the room. Suddenly cold
all over. I vowed I would
never ever look in my
Pressed Fairy Book
again!

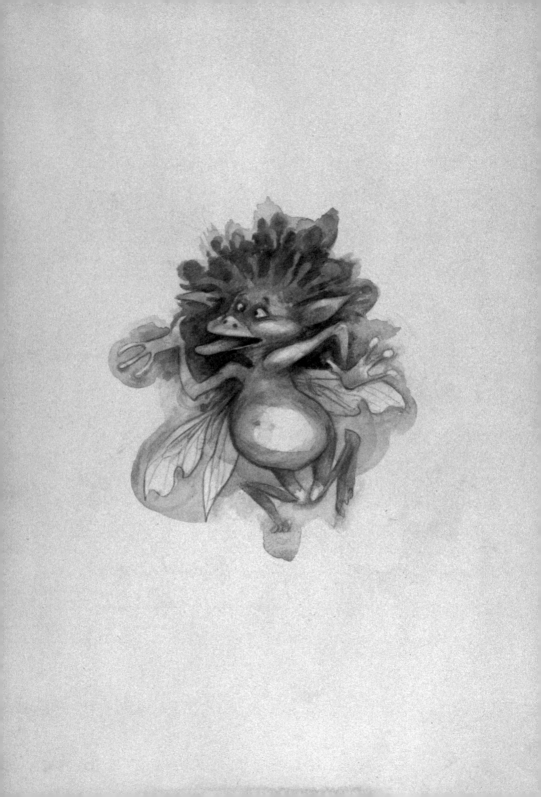

October 31st

November 1st
*Wet Wellington
Wednesday
(Imps and
Gremlins)*

November 2nd
*Fish-Returning Weekend**

*Fairies have a strange predilection for borrowing fish off each other. The fish are never eaten, but kept in odour-proof crystal boxes. Attempts to find out what the fairies actually do with these centuries-old fish, once they've borrowed them, or why they prefer other fairies' fish to their own, have been met with a resounding silence on the part of all fairies.

November 3rd
*Parsley Scattering
Season Ends*

November 4th

November

November 5th
GooseberryHumble's
Tummy-Rumbling Contest

November 6th
Potting Shed
Investitures
(Garden Fairies)

November 7th

November 8th
Wish-Granting
Championships
(Fairies)

November 9th
Wish-Granting
Championships
(Leprechauns)

November 10th
*Wish-Granting
Championships
(Sprites)*

November 11th
*Wish-Spoiling
Sports Day
(Imps, Gremlins, and
Grumpy Goblins)*

November 12th

November 13th
*Tooth Collection
Days Start
(Fairies)*

November 14th
*Works Getting Into
Championships
(Gremlins)*

November

November 15th
*Changeling Restitution Day
(Goblins)*

November 16th

November 17th
*Winter Welcome
Quadrilles and
Dainty-Sixes*

November 18th
*Hap-Dancing and
Tiger-Turning*

November 19th

November

November 20th
Beautiful Day

November 21st
Ugly Day

November 22nd
Dispute-Settling Assizes

November 23rd

November 24th
*The Third Bash of
the Tree-Toppers***

**The Tree-Toppers are well-known for their refusal to believe in the numbers "one" or "two". Despite scientific proofs and philosophical arguments to the contrary, the Tree-Toppers still start their numbering at "three" and carry on up to "pigteen" and "poultry".

November

November 25th
*Cat-Nipping
Convention*

November 26th
*The Day of the
Tan-Walloppers*

November 27th
*Bargle Day****

***Bargling is an ancient fairy activity with no human equivalent. The nearest thing to it in human experience would be to imagine yourself sliding around the inside of a giant's eyeball wearing a reproduction suit of yourself turned inside-out and marinating in mermaid's perspiration. But even that gives you no idea at all.

November 28th

November 29th
Fairy Flute Fantasy

November

November 30th
Whisp and Thread Fair

December 1st
*Carnival of Calendonia**

*Calendonia - that mythical city to which all fairies wish to retire after they reach a pensionable age and have sufficient imp-insurance to convince the Calendonia authorities that they will not become a burden on the city fathers.

December 2nd
Festival of the
Finger-Stalls

December 3rd
Fairy and Goblin
Taunt-and-Tease
Saturnalia

December 4th
Wind Whirling
Bacchanalia

December

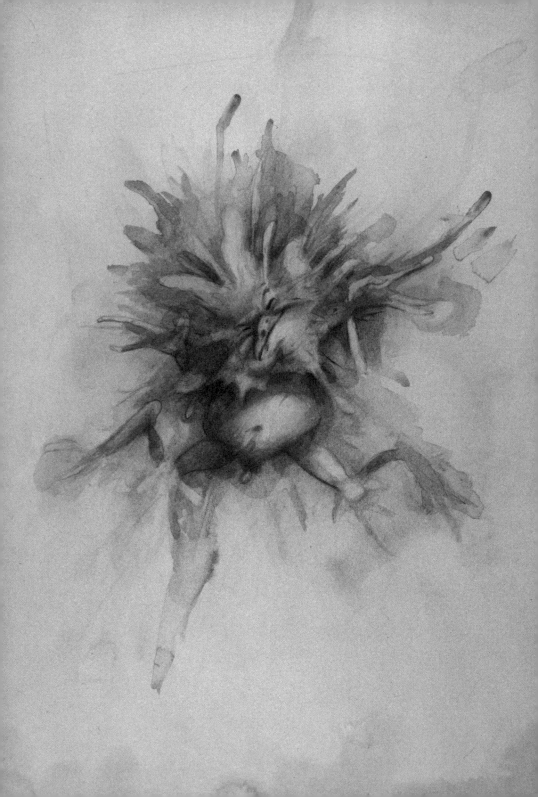

4th Dec 1906. Today I caught two more goblins. They really are horrid little creatures, and I have absolutely no regrets about catching them. One of them made an awful mess on my dress, however, and I had to pretend to my new Governess that I had spilt some paint on myself. I am sure it did it deliberately.

Today was also remarkable in another way. Cousin Nicholas arrived by the afternoon train. He came up to my room where I was working, and gave me an envelope. In it was the photograph I had taken all those years ago.

He would not tell me how he had obtained it, but begged for permission to publish it in the monthly journal for which he is now working. No matter how I resisted the idea, he found some way of countering my doubts, and I eventually gave my reluctant permission, save that my name be in no way connected to its publication.

At this moment, Cousin Nicholas put his arm around my waist and kissed me in a way that quite astonished me! I asked him what he thought he meant by taking such liberties. Whereupon he smiled and said: "I had always been a bit of a cold fish" or some such nonsense.

I began to wonder whether I had done right by allowing him to publish the old photograph.

December 5th
Dingle-Fritter, GooseberryHumple, Tiger-Get-By, LoneFolding and ZimberQuattor (Multiple Squashing of Celebration)

5th Dec 1909. Fairies thick and fast around my bed, in my wardrobe, under my washstand. What has got into them? They are like dust in the air.
"Go away! Shoo!"
I ran around my bedroom, snapping my book at them and catching them by the armfull. Dingle Fritter, Gooseberry Humple, Tiger Get By, Lone Folding, ZimberQuattor ... I recognise so many of them now and yet...
SNAP! I catch them between my pages by the dozen! By the end of it I can hardly shut the book !

December 6th
Days of Reckoning begin

December 7th
Day of Mourning for Dingle-Fritter, Gooseberry Humple, Tiger-Get-By, LoneFolding but not ZimberQuattor

7th Dec 1906. Surrounded by fairies in Church today. Some of them very insolent and prancking. I could not help snapping my prayer book at them. Caught one, but in future I shall bring my Pressed Fairy Book to Church with me.

December 8th

December 9th
End of Days of Reckoning

December

But GOD from infant tongues
On earth receiveth praise;
We then our cheerful songs
In sweet accord will rai :
Alleluia!
We too will sing
To GOD our King
Alleluia!

O Blessèd LORD, Thy
To us Th babes imp
And teach us in our
To know Thee as T
All
Then sh
To GOD
Alle

O may Th
Spread all the
And all with
Uplift the jo
Alle
All then s
To GOD th
Alleluia

" Jesus . . . took a chil
by Him
337
THERE 's a Friend for little children
Above the bright blue sky,
A Friend Who never changes,
Whose love will never die;
Our earthly friends may fail us,
And change with changing years,
This Friend is always worthy
Of that dear Name He bears.

There 's a rest for little children
Above the bright blue sky,
Who lov the Bless Saviour,
And in the FATHER's c
A rest from every turmo
From sin and sorrow fr
Where every li pilgrim
Shall rest etern ly.

There 's a home for little chil
Above the bright sky,
Where Jesus reigns
A home of peace an
No home on earth is like
Nor can with it compare;
For ever ne is happy,
Nor coul be happier, there.

There 's a crown for little children
Above the bright blue sky,
And all who look for JESUS
Shall wear it by and by;
A crown of brightest glory,
Which He will then bestow
On those who found His favour
And loved His Name below.

There 's a song for little children
Above the bright blue sky,
A song that will not weary,
Though sung continually;

song which even Angels
Can never, never sing;
They know not CHRIST as Saviour,
But worship Him as King.

There 's a robe for little children
Above the bright blue sky;
harp of sweetest music,
palms of victory.

Ah, above is treasured,
And ed in CHRIST alone;
rant Thy little children
Thee their own. Amen.

(Wisdom of God, as dear

end Thy bless-
red here, [ing
confessing,
loving,
pure;
David, proving,
death endure.

oly SA Who in meekness
Didst safe a Child to be,
Guide the steps, and help their
weak
Bless And make them like to Thee;
Bear Thy lambs, when they are weary,
In Thine Arms and at Thy Breast;
Through life's desert dry and dreary,
ing them to Thy heavenly rest.

S ead Thy golden pinions o'er them,
HOLY SPIRIT, from above,
Guide en, lead them, go before
them
them peace and joy and love
the temple HOLY SPIRIT,
ay they glory shine,
ment inherit,
And be Thine. Amen.

not ay to offer the first of
thy fruits."

IR waved the golden corn
In Canaan's pleasant land,
When full of joy, some shining morn,
Went forth the reaper-band.

To GOD so good and great
Their cheerful thanks they pour;
Then carry to His temple-gate
The choicest of their store.

Like Israel, LORD, we give
Our earliest fruits to Thee,
And pray that, long as we shall live
We may Thy children be.

Thine is our youthful prime,
And life and all its powers;
Be with us in our morning time,
And bless our evening hours.

December 10th

December 11th
*Nose-Scrambling and
Hair-Hiking Events*

December 12th
*Unmentionable
Thoughts Festival
(Goblins, Imps and
Naughty Fairies)*

December 13th

December 14th
*Unreturned Library
Books Sale
(Imps)*

December

December 15th
*Centipede Boot-Making
and Shoe-Repair
Season Starts*

December 16th

December 17th
*Feast of the
Fairy Godmothers*

December 18th

December 19th
Riddle-Making Trials

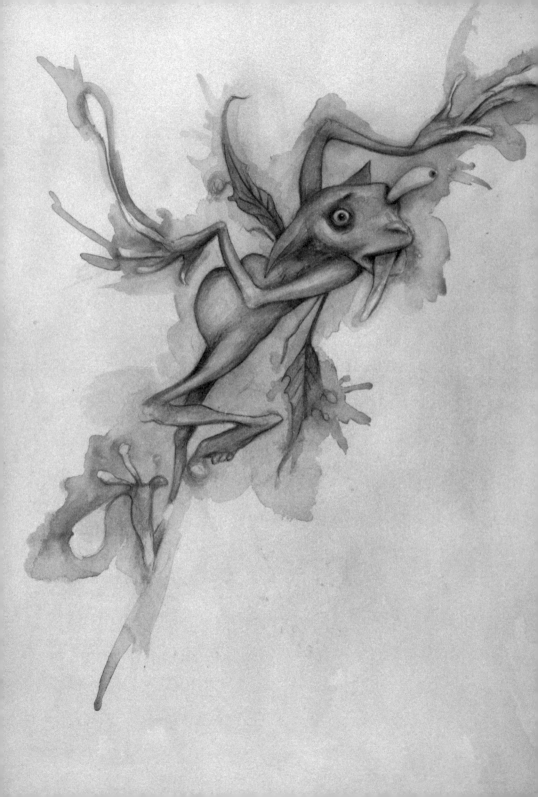

December 20th
*Snowflake-Riding
Championships
(No Goblins)*

December 21st

December 22nd
*Beetle Banquet and
Badger Ball*

December 23rd
Mouse-Marketing Day

December 24th
*Utter Day***

**Anything spoken or uttered on this day becomes a physical object and must be worn by the utterer for the rest of the day. It tends to be a very quiet time amongst the normally loquacious fairy-folk.

December

December 25th

December 26th
Unfairies' Gathering

December 27th

December 28th
*Fairy Academy of
Window-Frosting
Winter Exhibition*

December 29th

December

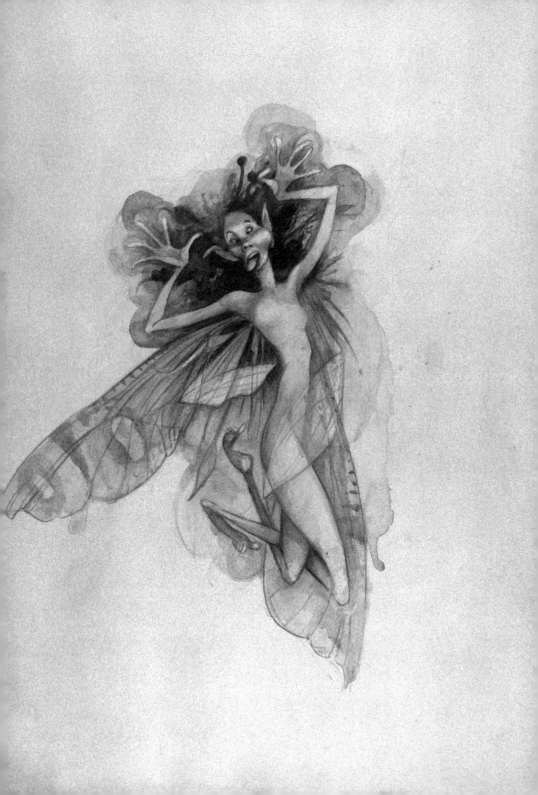

December 30th
Fairy Frequent
Fliers' Awards

December 31st
Fairy Eve's Year News

Dec. 1912. I fear the fairies have given me up for good. All I can do is turn the pages of this book and remember them all...

December